I imagine a world without Alzheimer's Disease.

For me, this book is a passion project. My father, Sargent Shriver, was diagnosed with Alzheimer's in 2003, and passed away in 2011. Throughout his entire disease, I sought things I could do to bring me closer to him. I wish this coloring book had existed during that time. It would have been something we could have done together—something my children could have done with him, or something he could have done with friends when they came to visit. The truth is, Alzheimer's doesn't only affect the people who are diagnosed; it affects everyone in the family, and everyone who knows that person. My hope is that this book can offer people with Alzheimer's and those with dementia or other brain-related challenges an opportunity to try something new, and offer caregivers and loved ones ideas for activities and conversation. For all those affected by Alzheimer's—patients and those in their circle of love and support—I hope this book helps to show how you care for each other. There are good times to be had together, and so many opportunities to form new cherished memories.

My commitment to fighting Alzheimer's goes beyond the pages of this book. I challenge the belief that there is nothing we can do to prevent, reverse, or cure this disease. I am determined to find out why Alzheimer's disproportionately affects women, so I am raising awareness and money to support gender-based research. I believe that by studying Alzheimer's in women, we will find a cure for everyone. Fighting this disease is my mission.

I imagine a world without Alzheimer's. I hope you will, too.

Join me!

Love,

Maria Shriver

Blue Star
COLORING

Published in 2017 by
Blue Star Coloring
An Imprint of Blue Star Press
Bend, Oregon
contact@bluestarcoloring.com
www.bluestarcoloring.com

Illustrated by
Brita Lynn Thompson
@zenspiredesigns
www.zenspiredesignsetsy.com

Designed by Chris Ramirez

• •

This book belongs to

...

How to Use This Book

COLOR YOUR MIND is a ground-breaking book filled with both information and inspiration. This project was undertaken with great love and a deep sense of hope and purpose. Created with insights from caregivers, neurologists, psychologists, and, of course, people with Alzheimer's, it is written as a resource for caregivers, family, and friends to help forge communication and connection with people with Alzheimer's or other forms of dementia.

Coloring is a creative outlet, a way to relieve stress, and even a way to connect with other people—all benefits that contribute to overall well-being. Yet, *Color Your Mind* is more than just a coloring book! Throughout this book, you will find coloring pages, activity suggestions, and ideas for shared reflection and conversation. This book is unique in that it connects coloring with helpful information surrounding well-being, social connection, nutrition, exercising the body, moving the mind, and sleep—all valuable lessons for a fulfilling, balanced life.

· · · · · · · · · · · · · THREE THINGS TO KNOW · · · · · · · · · · · · ·

1. This book is written for caregivers, family, and friends to use to connect with their loved one, finding joy and closeness in a shared activity or conversation. I hope it helps you to create new memories to cherish!

2. Coloring is an inherently fun, calming activity. People with Alzheimer's should feel empowered to begin any page at any time, coloring only until they no longer feel like it.

3. If your loved one cannot remember certain things, please be patient. Some of the most profound conversations with my father came out of nowhere; it's important to just hang in there.

ORGANIZATIONAL OVERVIEW

The six chapters focus on topics that influence quality of life and brain health.

Well-Being · **Social Connection** · **Nutrition** · **Exercise** · **Move Your Mind** · **Sleep**

Found at the beginning of each chapter, "Maria's Tips" provide personal insight and inspiration.

Each chapter opens with a topical overview that explores a way to encourage wellness and healthy living for people with Alzheimer's.

TIPS FOR TIME TOGETHER

Learn, teach, and color with your loved one.

Every coloring page is accompanied by a relevant piece of information for you to share with your loved one.

CREATE prompts provide easy-to-follow instructions for the coloring activity.

CONNECT prompts go a step further, with suggestions for activities and ways to connect with others.

REFLECT prompts focus on "yesteryear," with questions that may help to evoke memories from long ago.

The level of complexity in the colorable designs in this book ranges from simple to moderately complex. Regardless of the level, here are two examples of how to approach coloring the designs in this book.

Let's Have Fun!

THE COLOR WHEEL

Color surrounds us from morning to night, present in every conceivable way. Warm colors like yellows, oranges, and reds may suggest intense feelings of energy or passion. Cool colors like blue and purple are associated with calmness, or creativity. Many people are strongly drawn to specific colors. Color can be surprisingly powerful! The bright, friendly colors featured throughout this book were chosen intentionally to convey a feeling of cheerfulness and fun.

Caregivers, family, and friends can guide their loved one to select from the color wheel to color the words on the following page. Or, choose any other colors he or she is drawn to!

NOURISH

encourage *Move*

JOY PERSIST

CHERISH

Learn *energize*

inspire HOPE

CONNECT

CREATE *fun*

Let's Get Started!

After reviewing the color wheel, you're ready to put it to use! Caregivers, family members, or friends can encourage their loved one with Alzheimer's to mimic the colors in the vibrant butterfly while coloring the image on the following page. Enjoy the relaxing, rewarding experience of coloring your first image.

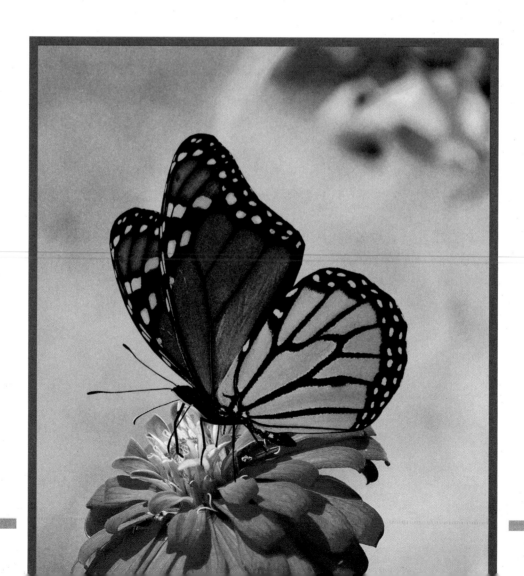

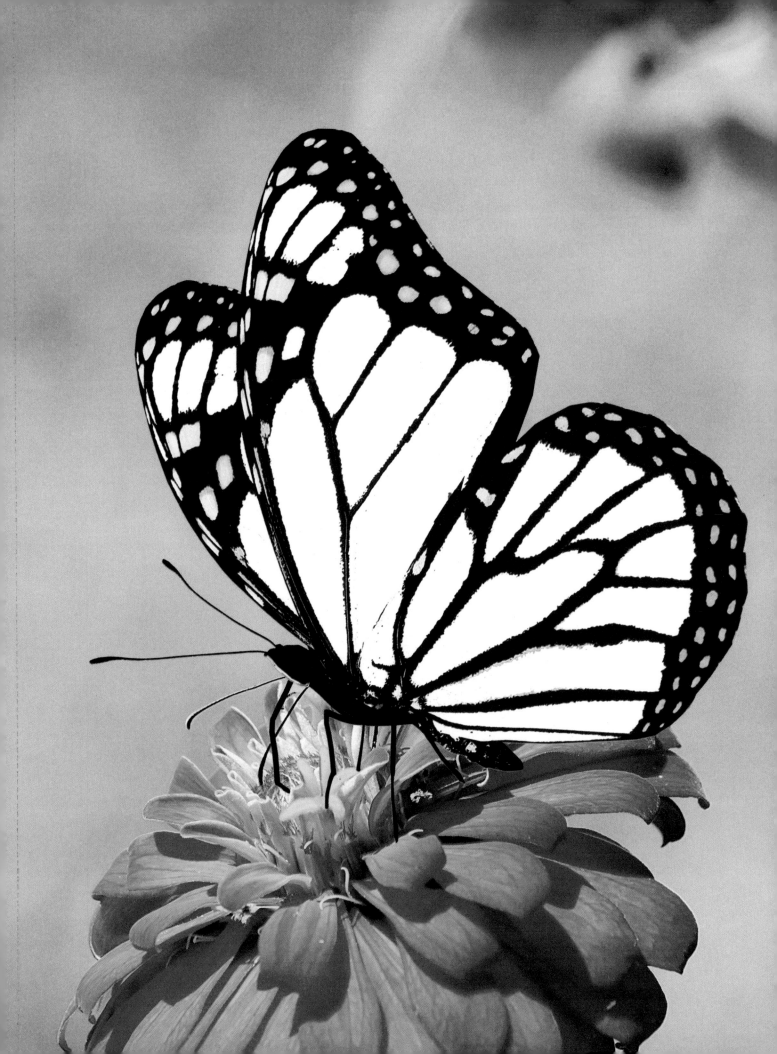

Well-Being

TO *LIVE WELL* IS AN ART—one that is influenced by the cultivation of daily habits and practices that can enrich one's life. While some stress in life is inevitable, research tells us that chronic stress can be damaging to our physical and psychological health. Thankfully, many of the effective tools for coping with mental and physical stress are likewise practices that promote well-being.

This chapter focuses on the various facets of well-being: the importance of maintaining a positive attitude, of practicing gratitude, of learning throughout one's life, and of having a daily routine.

MARIA'S TIP

Write It Down!

Writing a note to yourself is a powerful, yet simple practice. You can make a list of things you're thankful for. You can make note of something you would like to learn. Or, you can jot a reminder note to help you maintain a routine!

You Are Not Alone

Alzheimer's Disease and other dementias affect the person who is diagnosed; however, the family and friends who share in this experience are also profoundly impacted. To people with Alzheimer's and those who love and care for them: *You are not alone!* You have my support—and that of so many others—to accompany you on this journey.

We are both the givers and recipients of love throughout our lives. When we remain patient, open, and receptive, we can experience connection and love in so many different ways.

CREATE

Color the image on the following page. Think of the many people who love and care for you. When you have finished coloring, you may want to hang this picture in your room as a reminder that you are loved, and that *you are not alone!*

CONNECT

Have a conversation or write a letter to someone you care about. What things would you like to tell them?

REFLECT

What are some ways you have shown extraordinary care and love for others in your life?

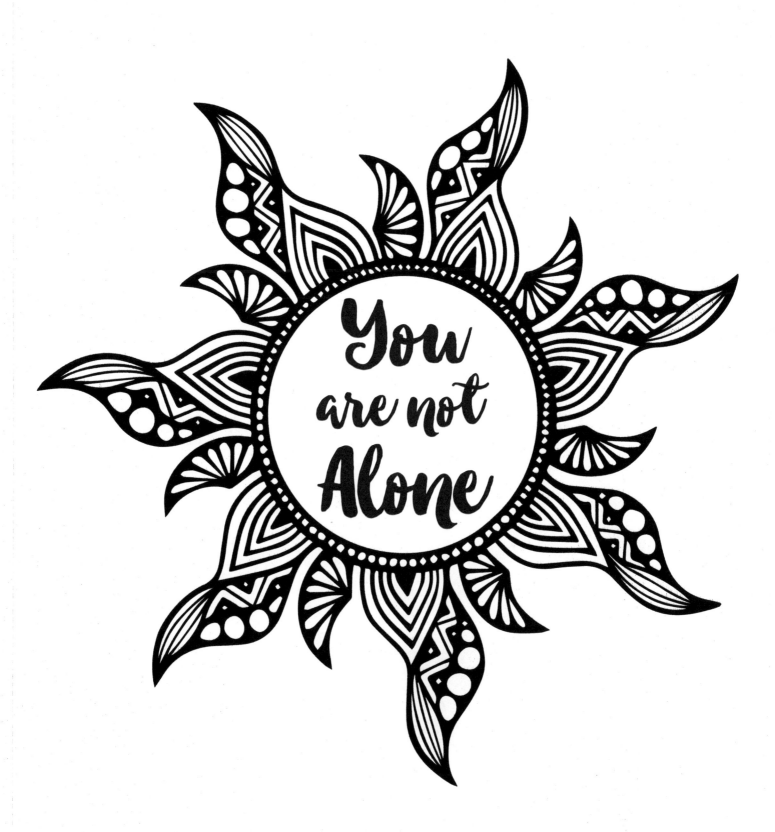

Learn Something New

Acquiring a skill or taking up a new hobby is a great way to keep the mind active and to keep life fresh and interesting. It's alright to start slowly; improvement will come with time and practice!

Blue

Green

1 Blue **2** Green **3** Violet

CREATE

As you begin to color, the color-by-number image on the following page is a good warm-up activity. Simply use the colors that correspond with the numbers to get started.

CONNECT

Trying new things and exploring different activities are excellent ways to keep your brain active. These interests also offer opportunities to connect with other people. What are some of your interests and hobbies that can be shared with others? Do you know anyone who may enjoy coloring with you?

REFLECT

What were some of your interests and hobbies when you were a young person? Were these consistent throughout your life, or did you develop new interests?

Stay Positive

A positive attitude impacts our lives, and the lives of those around us. Life can be full of challenges, but difficult times often reveal profound lessons. Though sometimes easier said than done, a conscious decision to focus on the positive will help us to recognize beauty and grace in our lives and move forward through even the most trying times.

CREATE
As you color the image on the following page, think about who and what adds joy and happiness to your life.

CONNECT
What life experiences have you had when a positive attitude made a difference?

REFLECT
What are some other important life lessons you have learned?

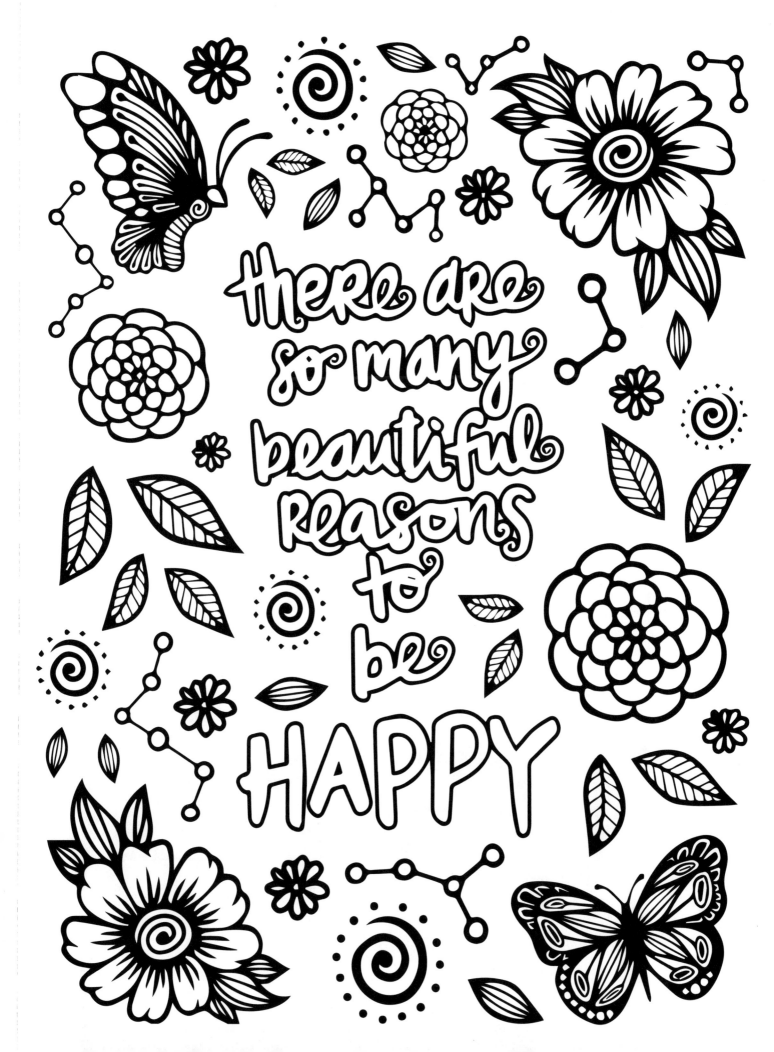

Practice Gratitude

The simple act of being thankful can have a significant impact on our lives. Research shows that practicing gratitude is consistently associated with greater happiness in life. There are many ways to experience gratitude, such as recalling cherished memories from the past, or pausing to be thankful for small moments during the day. Every day when I get up, I say what I'm most grateful for. I repeat this practice when I go to bed at night. This has been helpful for me, and I hope it's something others try to incorporate into their lives, too!

EXAMPLE

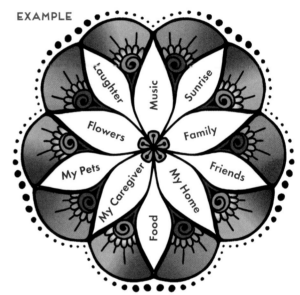

CREATE

What are some things you are grateful for? List ten things you are thankful for in the large petals of the colorable design on the following page, then color it in your favorite colors.

CONNECT

Is there a particular person in your life for whom you are grateful? Call this person or write a letter to tell them what they mean to you.

REFLECT

Every one of us has different reasons to be thankful. Many people are thankful to know and love *you*! Think of the people who are thankful for *your* presence in their lives.

I AM GRATEFUL FOR...

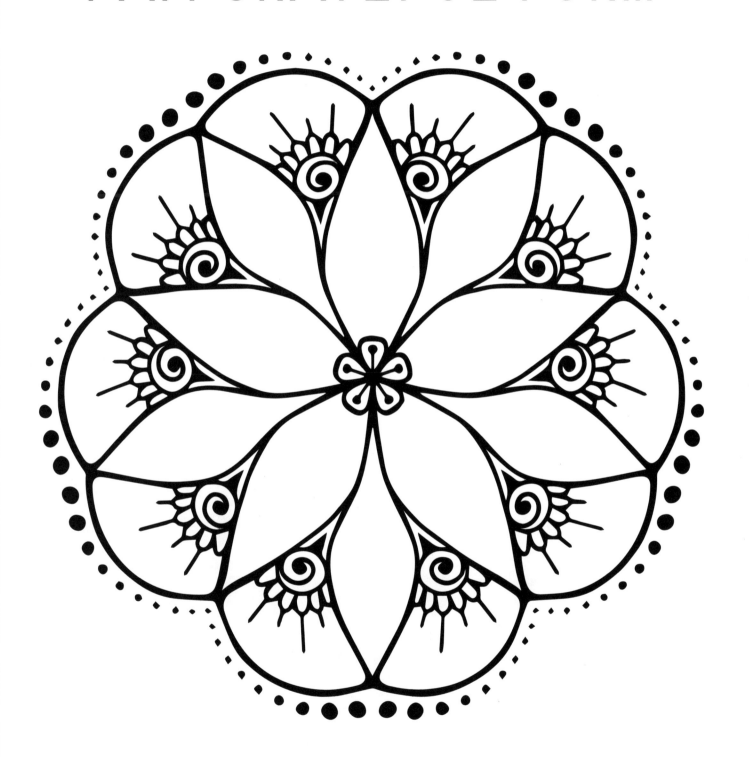

Have a Routine

Consistent routines can be quite important—consider how a professional athlete relies on a training regimen. Simple tasks performed regularly can help to create a consistent, reliable structure to the day that may be comforting to people with Alzheimer's, and may provide a rewarding sense of accomplishment. Over time, daily habits become the backbone of a fulfilling daily life.

CREATE

As you color the pattern on the following page, enjoy the repetition of the image. Think about your own daily habits and routines. Perhaps you can color one part of the design today, and save the others parts to color on different days. As you color new design pieces, enjoy the feeling of accomplishment as you complete more and more of the page.

CONNECT

What routines would you like to introduce to your day? Write a goal for tomorrow on a piece of paper. For example, if you enjoy coloring, try setting aside the same time each day to color.

REFLECT

Think back to when you were young. What routines or habits were important to you? Did you enjoy going for a run? Did you have a favorite time to study? What was your favorite television program or radio show?

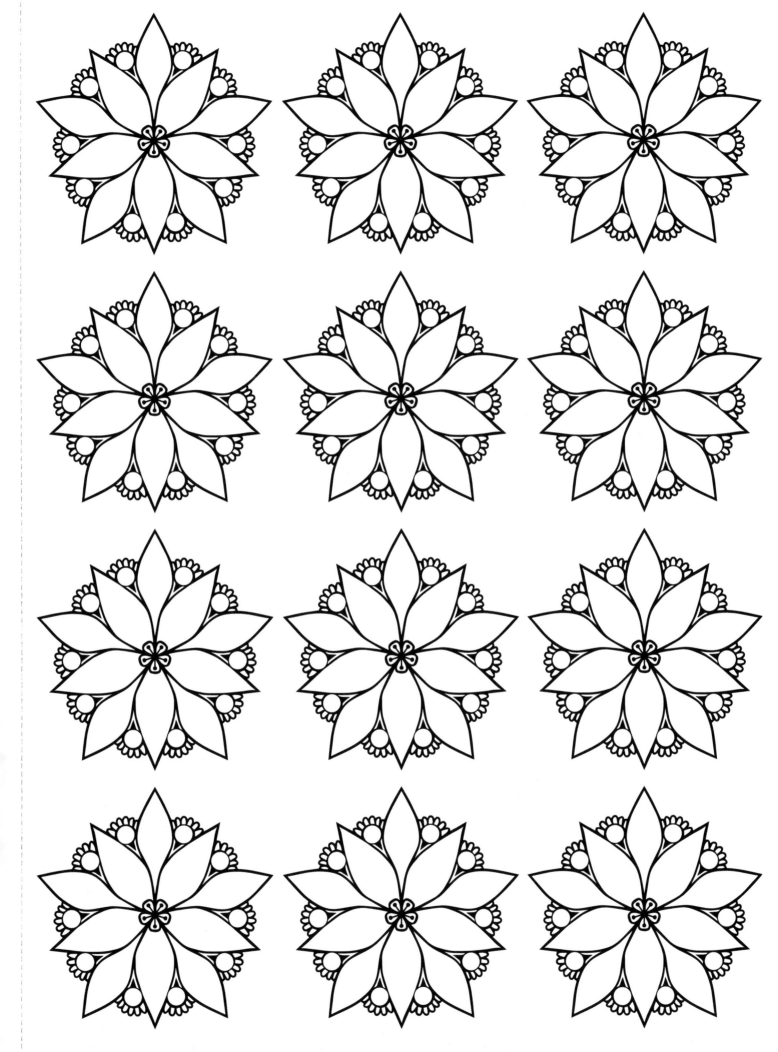

Social Connection

MARIA'S TIP

Stay Connected!

It's so important to stay connected to a supportive circle of friends and family. Reach out to those around you. Be open to new friendships, and nurture those friendships that are long-established. Strong bonds and relationships are a key part of a happy, fulfilling life.

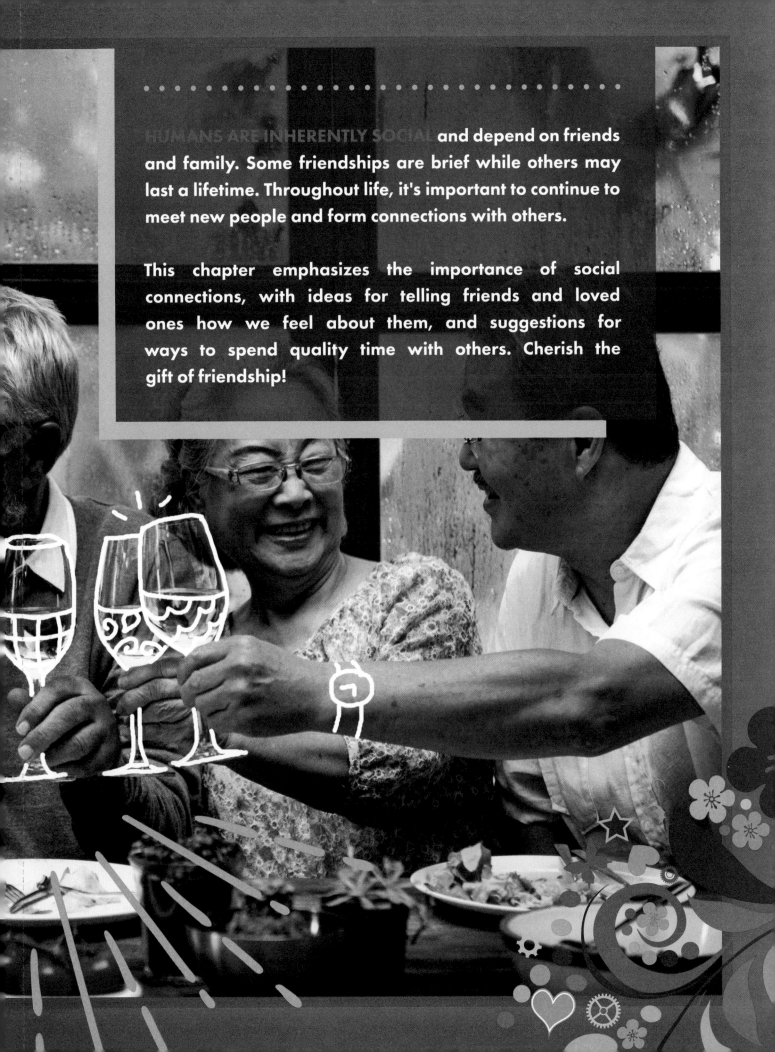

HUMANS ARE INHERENTLY SOCIAL and depend on friends and family. Some friendships are brief while others may last a lifetime. Throughout life, it's important to continue to meet new people and form connections with others.

This chapter emphasizes the importance of social connections, with ideas for telling friends and loved ones how we feel about them, and suggestions for ways to spend quality time with others. Cherish the gift of friendship!

Color for a Friend

It is better to give than it is to receive, so the saying goes. And it's true! (Although everyone who knows me knows that I love a fun gift.) A heartfelt piece of artwork is a wonderful, personal way to let someone know you're thinking of them. In fact, my most prized possessions are pieces of artwork done by members of my family.

CREATE
Color the image on the following page, and give it to someone you care about.

CONNECT
Try writing a personal note to one of your friends. Who will you choose? What would you like to tell them? Be sure to ask your caregiver or a loved one if you need assistance writing your note.

REFLECT
Did you have a best friend growing up? What kinds of things did you like to do together?

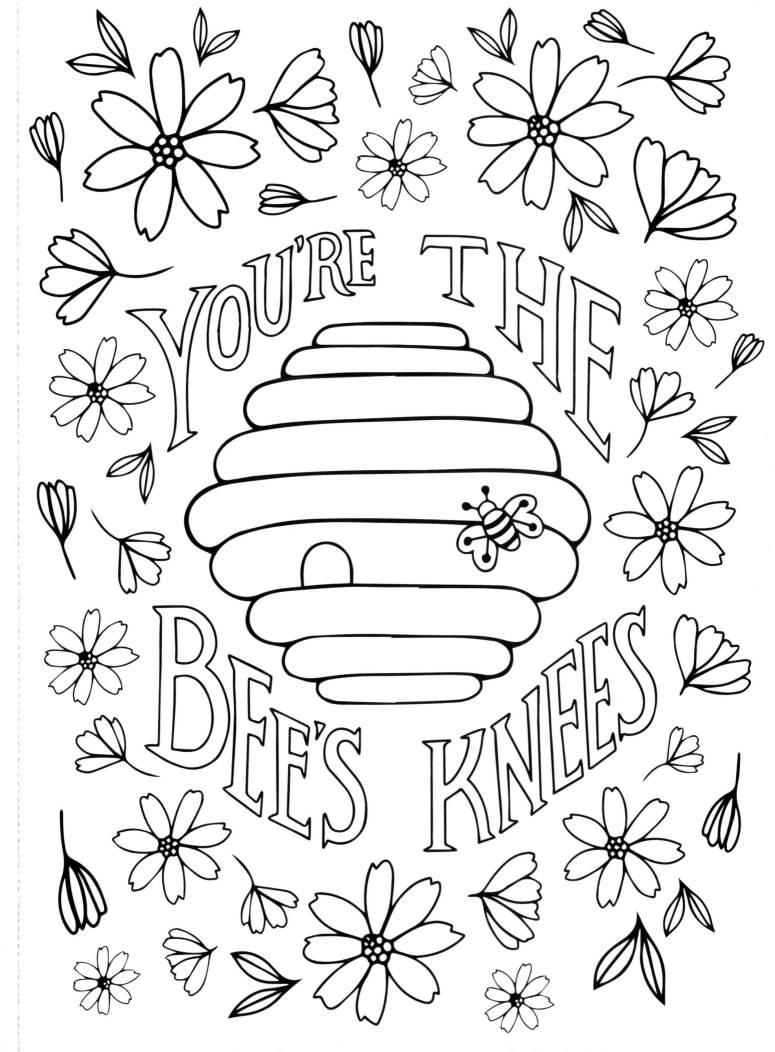

Have a Coloring Party

There is no feeling quite like being in a room filled with family and friends. When you share interests with people you care about, time spent together is even more fun! A coloring party is an excellent way to spend time with others and it may even be an opportunity to make new friends!

CREATE
Who will you invite to your coloring party? Ask a loved one or your caregiver to help you get ready for the party. Together, make a list of friends and loved ones to invite, and make copies of this page for each guest. Set out colored pencils, crayons, or markers, turn on some music, and have fun!

CONNECT
Are any of your friends doing a really great job while coloring? Tell that person how much you like his or her creation!

REFLECT
What fond memories do you have of parties you have attended? What were the occasions?

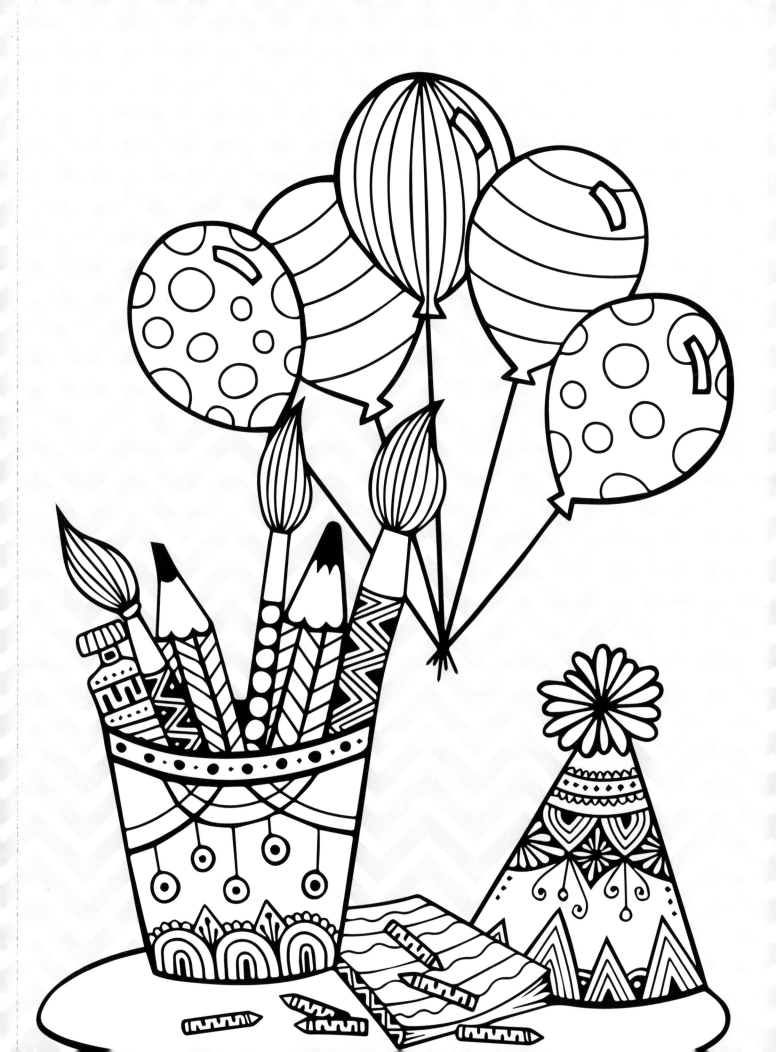

Play a Game

Shuffleboard, bridge, chess, and my favorites, UNO® and "Go Fish"—games can be a fun way to move around, or a backdrop for funny jokes and good conversation. Games can keep your mind active, or may simply be a way to pass an enjoyable afternoon! Whichever of these is true for you, games are an excellent way to connect and celebrate time with friends and family.

CREATE
Color the image on the following page and think about some of the games you like. Which ones are your favorites?

CONNECT
Do you have a jigsaw puzzle? When was the last time you played checkers, or a game of cards? Consider inviting a friend to play a game with you, or make some progress on a puzzle today!

REFLECT
Are you drawn to active, outdoor games, like croquet, or to games that can be played quietly indoors? What were some of your favorite games to play as a child?

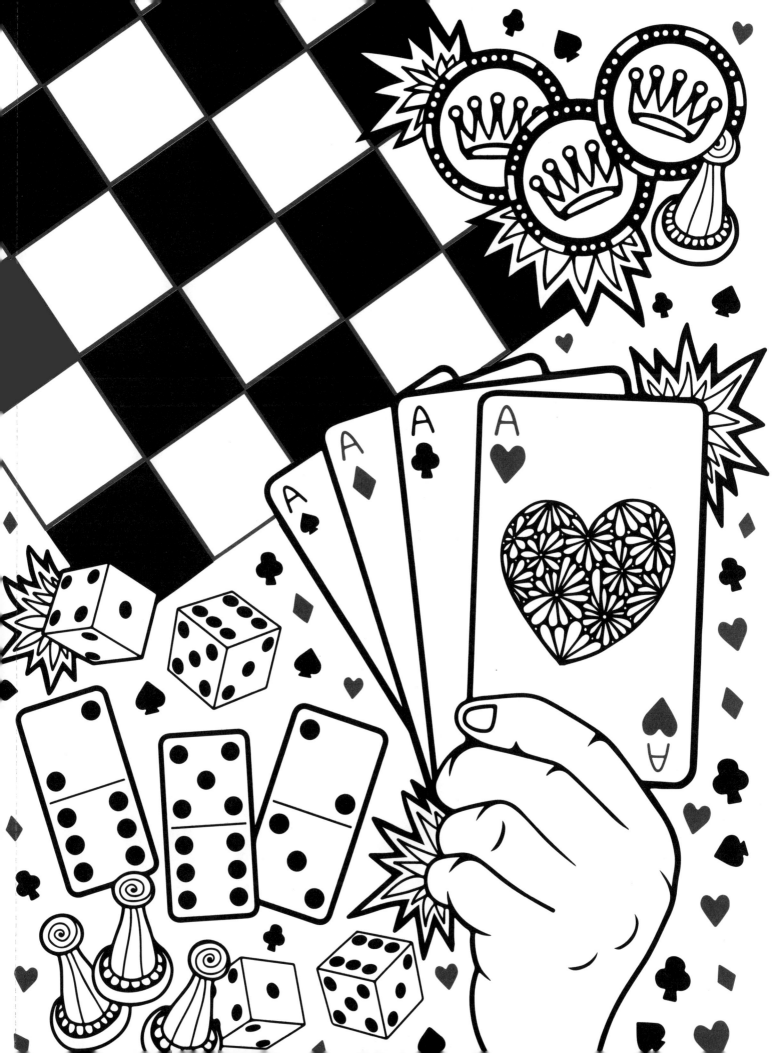

Color With a Friend

Friends are people we enjoy spending time with, and who are there for us when we need them. Sometimes, a task that may seem daunting can be easily overcome with a friend's help or encouragement. Or, it may simply be fun to spend time with a friend for companionship and conversation!

CREATE
Invite someone to help you color the large butterfly. Remove the folded page from the book and spread it on the table between you. You can use the sample butterfly as a guide, or choose your own colors. The final result may not be identical on both sides, but it will be all the more beautiful because you worked together!

CONNECT
Coloring with a friend is a different experience from coloring alone! Before you start, take time to plan and choose the colors you want to use together. Do you and your friend like the same colors?

REFLECT
Animals can be our friends, too. Did you ever have a pet who was special to you?

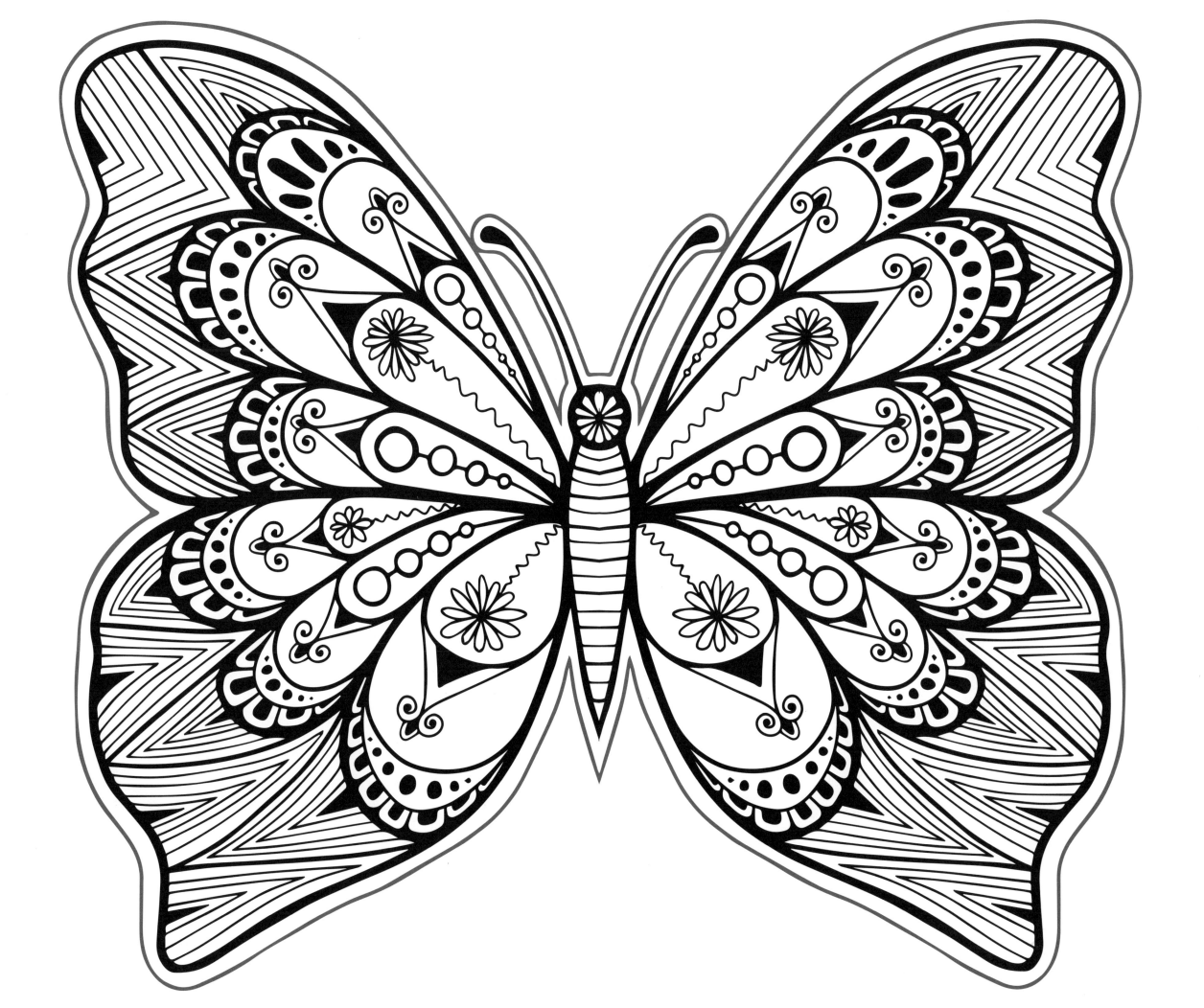

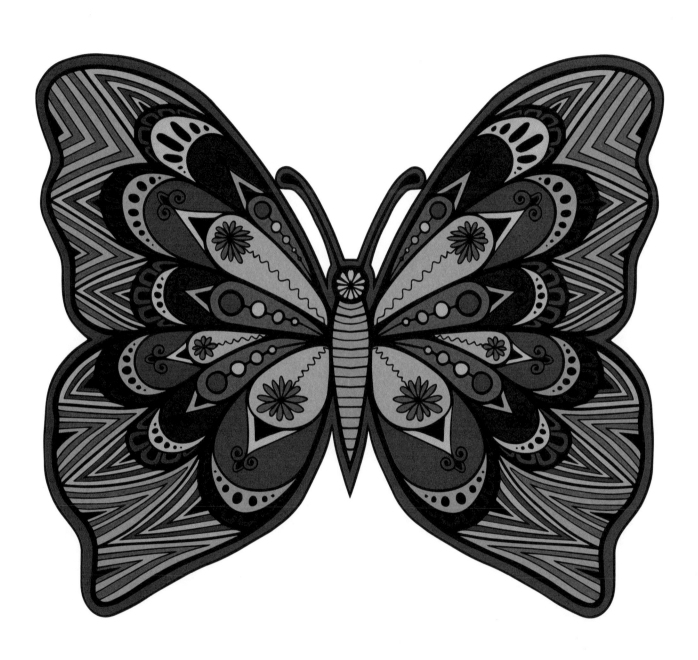

Nutrition

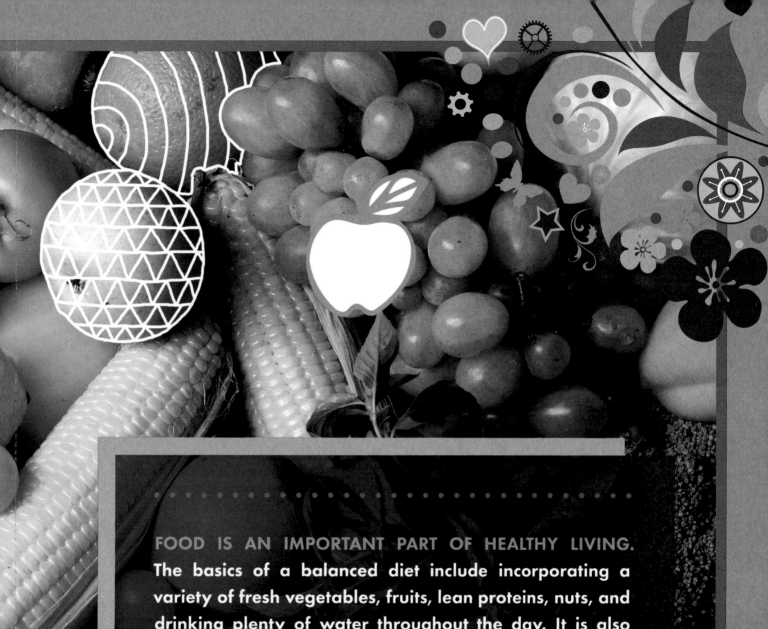

FOOD IS AN IMPORTANT PART OF HEALTHY LIVING. The basics of a balanced diet include incorporating a variety of fresh vegetables, fruits, lean proteins, nuts, and drinking plenty of water throughout the day. It is also important to avoid processed foods whenever possible. Food affects not only our bodies, but also our brains.

This chapter discusses how healthy eating supports our well-being and nourishes both the body and the mind. It acknowledges the importance of also enjoying our food, and offers suggestions for staying well-hydrated. It's important that people with Alzheimer's should consult with their doctor about which diet is right for them.

*Please consult a doctor or dietitian before consuming grapefruit, plums, kiwis, blueberries or making any changes to your current diet.

Add Color to Your Diet

The image below is full of vibrant color! Deep purples, rich reds, and vibrant greens are nature's way of showing us how to get a variety of nutrients in our diet. We know that a varied, well-balanced diet is essential for optimal body and brain function.

Use the image below as a guide while you color on the following page. Don't forget to enjoy real, colorful veggies in your diet as well!

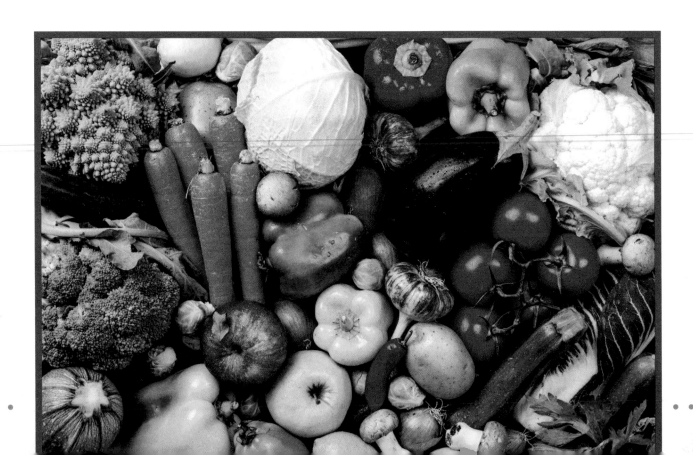

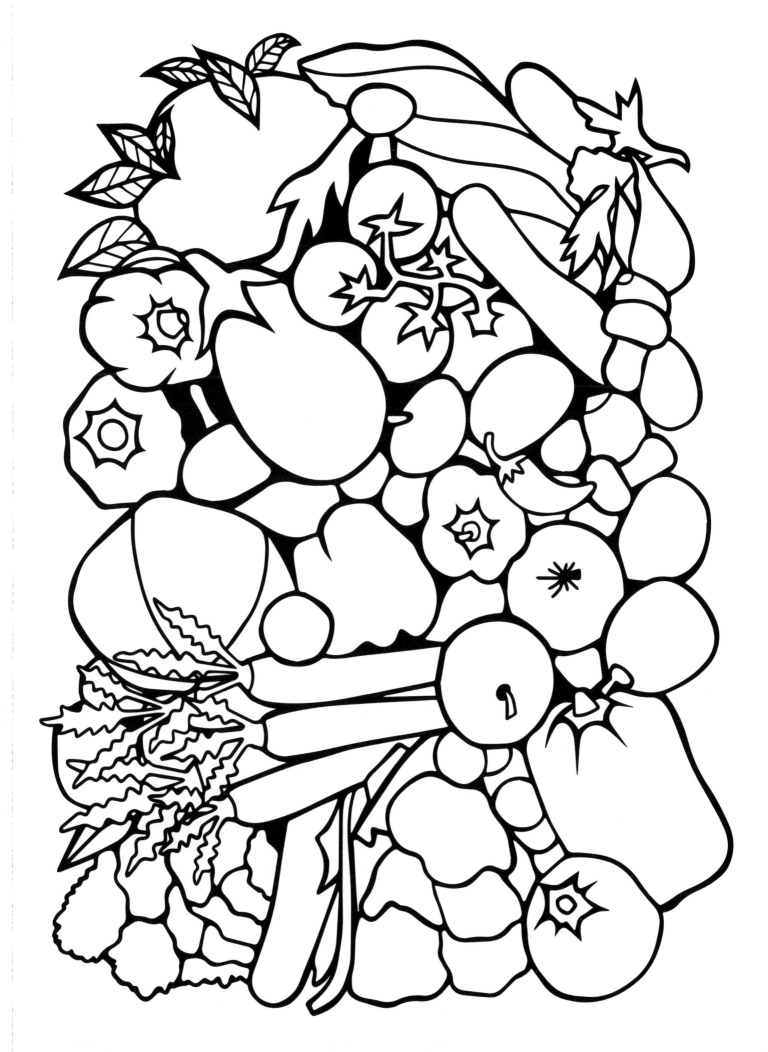

Eat Healthy

Fruits, vegetables, lean proteins, whole grains, and legumes are food groups that help to promote a healthy lifestyle. A balanced diet fuels the body and brain alike. With so many wonderful foods to choose from, there are many options for a varied, healthy diet. Patients should discuss their specific dietary needs (and potential restrictions) with their physician before making any dietary changes.

CREATE
As you color the examples of healthy foods on the following page, think about how good food makes you feel!

CONNECT
What are some foods you should eat sparingly? Why? Have a conversation with a loved one, caregiver, or doctor about the types of healthy food you would like to eat!

REFLECT
Think of a wonderful meal you have enjoyed in the past. What was the occasion? Was the meal homemade, or at a restaurant? Who was with you?

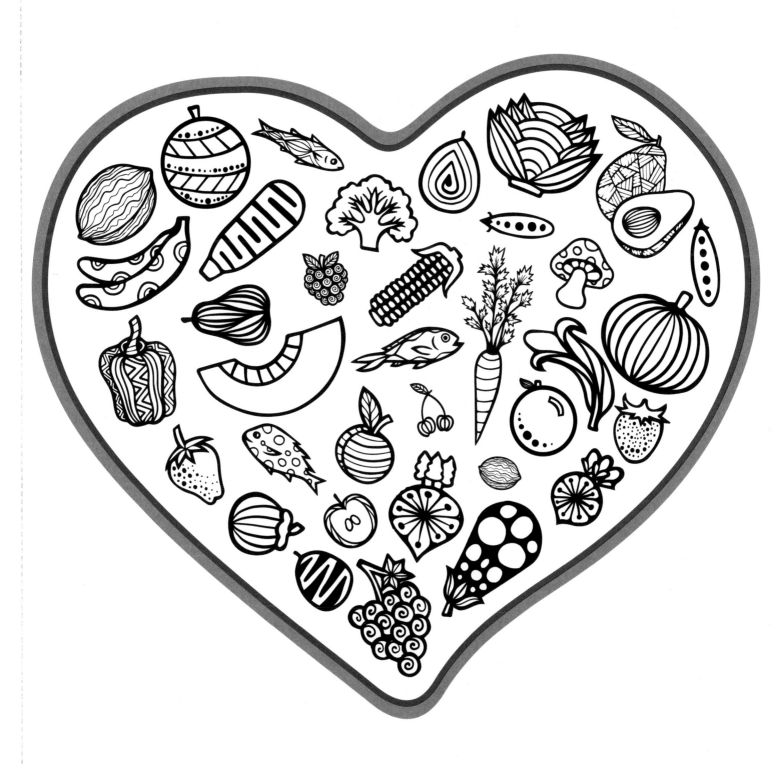

Treat Yourself

Although it's true that food is meant to nourish, it is also meant to be enjoyed! It's perfectly natural to want to indulge or seek out "comfort food" from time to time. Here is a secret, though: some "treats" can also be healthy!

Consider dark chocolate. Not only is it delicious, but studies have shown that when eaten in moderation, dark chocolate can improve mood, concentration, learning, and memory! Dark cacao contains beneficial antioxidants, vitamins, and minerals. People with Alzheimer's should check with their doctor or dietitian; he or she can help to determine ideal treats.

CREATE
Enjoy a favorite treat and color the sweet design on the next page.

CONNECT
Find a delicious, healthy recipe with your caregiver and make something tasty together.

REFLECT
What treats do you enjoy? Have you ever received something sweet as a gift? What was the occasion?

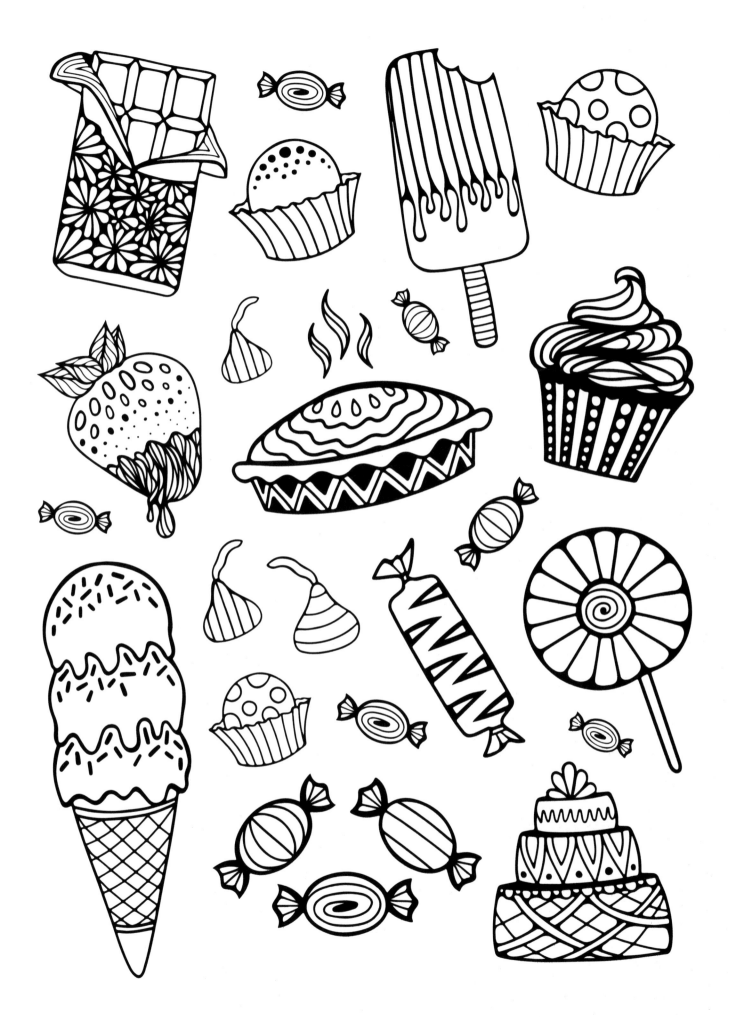

Drink Water

Water is crucial for essential body and brain functions. Dehydration can cause irritability, confusion, fatigue, and dizziness. Staying hydrated is so important! Be sure to drink more water than usual on hot days or when physically active.

CREATE
Color the design on the following page in cool, blue tones. Think about how water is essential for your body.

CONNECT
What simple steps can help with your water goals? Try asking for your own personalized water bottle. You can even put your coloring skills to use to make a colorful label for your water bottle. Ask your caregiver or a loved one to help you fill up your bottle every morning as a part of your daily routine.

REFLECT
Think of a time when you physically exerted yourself. Perhaps you ran a race, or worked in the garden on a warm day. Was a cup of cool water refreshing to you?

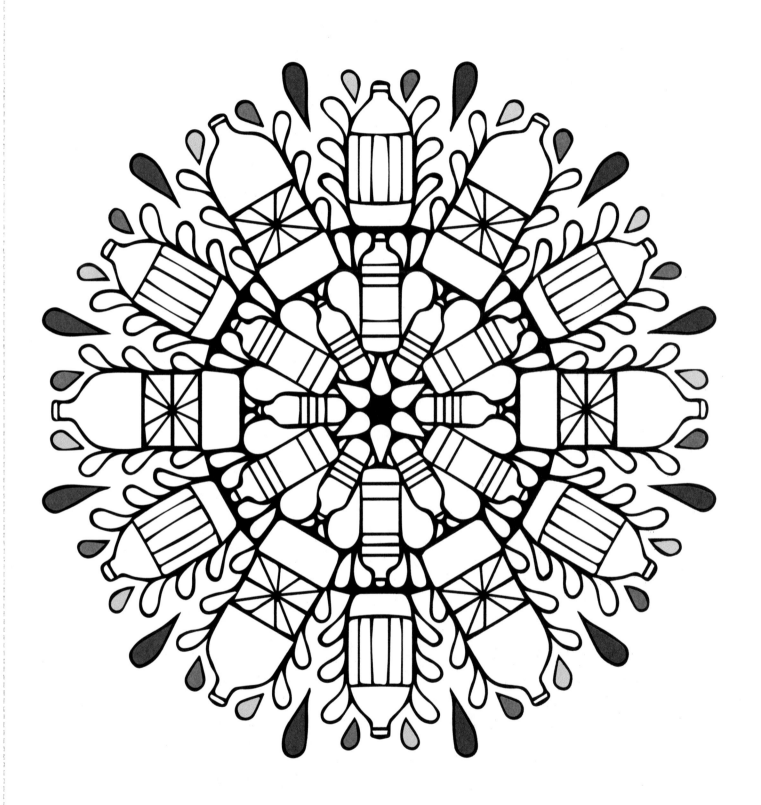

MARIA'S TIP

Move Your Body!
Exercise has so many benefits. It keeps your body strong, as well as your mind. Did you know that exercise is an incredibly effective way to relieve stress? When your body is moving and your blood is pumping, you will release negative energy and feel your mood lift. How will you choose to exercise each day?

Exercise

THE MIND AND BODY WORK IN CONCERT: to exercise the body is to exercise the mind. Every doctor I've spoken to regarding Alzheimer's emphasizes that a crucial factor that influences cognitive health is exercise!

Exercise can take many forms, but the most important thing is to find a way to stay active and to exercise regularly and safely. This chapter reviews the importance of routinely stretching and offers suggestions for easy, accessible exercises including dancing, gardening, or taking a nature walk with your caregiver to help find what works the best for you.

Stretch Your Body

The body is a set of connections: bones, nerves, tendons, and muscles. They all work together in harmony with the brain to make each person truly unique.

However, modern life has made us overly sedentary. We are so accustomed to sitting for long periods of time without moving a muscle! It's important to move and stretch regularly. Start with safe, simple, seated stretches. People with Alzheimer's should talk with their caregiver or doctor about stretching and other more advanced moves. Perhaps introducing a yoga practice is a rewarding option. Yoga combines stretching, exercise, and deep breathing, and has many health benefits. We all sit too much, so be sure to get up and MOVE!

CREATE
Color the image on the following page. Notice how your body feels as you color.

CONNECT
As you color, does your neck or back begin to cramp as time goes by? If this happens, take a break. While seated, spend a few minutes gently stretching your body—neck, shoulders, even your hands. When you resume coloring, what do you notice about how your body feels?

REFLECT
Has stretching been a part of your routine during different parts of your life? Why did you stretch, and how did it make you feel? How can you incorporate gentle stretching into your daily routine now?

Move Your Body

After stretching, simple and safe exercises can be attempted. People with Alzheimer's should consult with their doctor before introducing an exercise routine. After doing so, here are some ideas for safe exercises that can be done with a caregiver's supervision:

- Hold arms out to the sides and rotate at the shoulders.
- Step each foot forward and back. Alternate for one minute.
- Gently turn the head side-to-side then up and down. Repeat for 15 seconds.
- For more advanced exercises, consider incorporating resistance training.
- Pay attention and remember to breathe while exercising.

CREATE
After you exercise, relax as you color the pattern on the following page. Think about how important it is to move your body.

CONNECT
Ask your friends how they like to exercise! Are there any ideas that sound interesting to you? With your doctor and caregiver, discuss options for new types of exercise you can try to increase your levels of daily physical activity.

REFLECT
Remember that humans have a powerful mind-body connection. Physical activity is certainly good for the body, and it is also good for the brain! Did you have a favorite sport you liked to watch or play when you were younger?

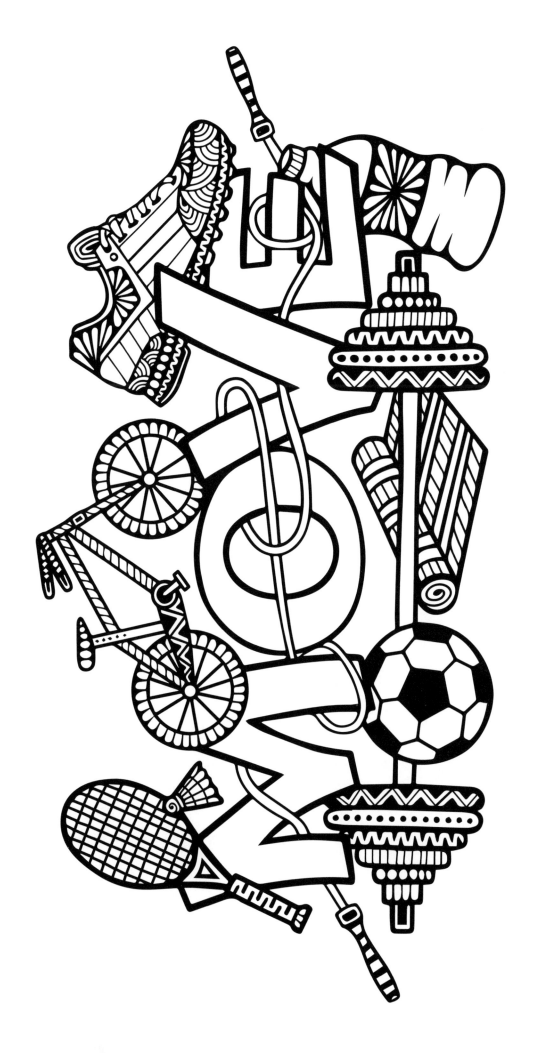

Dance!

Dance has a language all its own. On top of being a lively way for people to express themselves, dancing is an excellent form of exercise—and it is just plain fun! Even for people with limited mobility, there are many options for modified forms of dance: one can dance moving only the upper body, hands and arms, and moving the body in time with the music while seated. Turn on music, smile, and MOVE!

CREATE
Color the dance pattern as you listen to some favorite songs. Do you find yourself moving in time to the music?

CONNECT
Are there certain songs or a particular type of music that just make you want to move? With your caregiver or a friend, think of songs that make you want to dance. Make a playlist you can listen to when you feel like dancing!

REFLECT
Do you remember the first time you danced? Do you have other special memories of dancing?

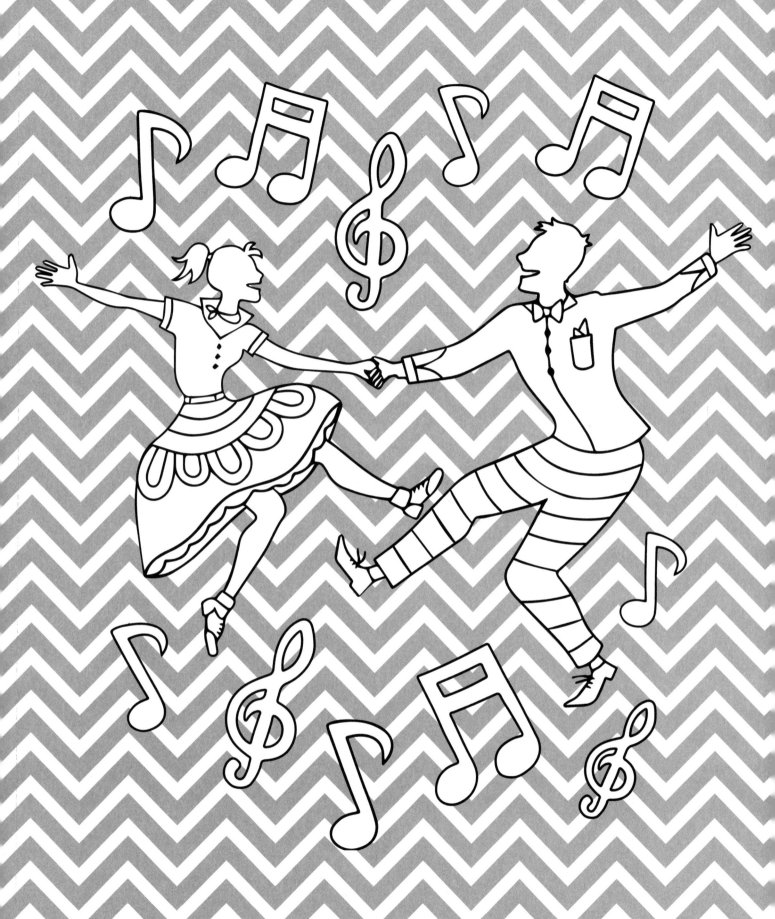

Garden

Spending time in the garden and in nature is a good way to get fresh air and light exercise. Gardening engages all the senses, and delights the body, mind, and spirit.

If working in the garden, be sure to wear a sun hat, gardening gloves, and other appropriate clothing to protect from the elements. People with Alzheimer's should take another person with them, or tell someone if they are heading outside. It's also smart to bring a water bottle!

CREATE
The pattern on the following page has some essential gardening supplies. When you color the pattern, use colors you might see in a garden!

CONNECT
Do you like to bring nature indoors, too? Do you have a favorite flower? Find fragrant flowers to bring home with you to fill your space with vibrant color and a beautiful scent.

REFLECT
Have you ever kept a garden? Did you grow flowers, or food? What do you enjoy about gardening? What would you most like to grow?

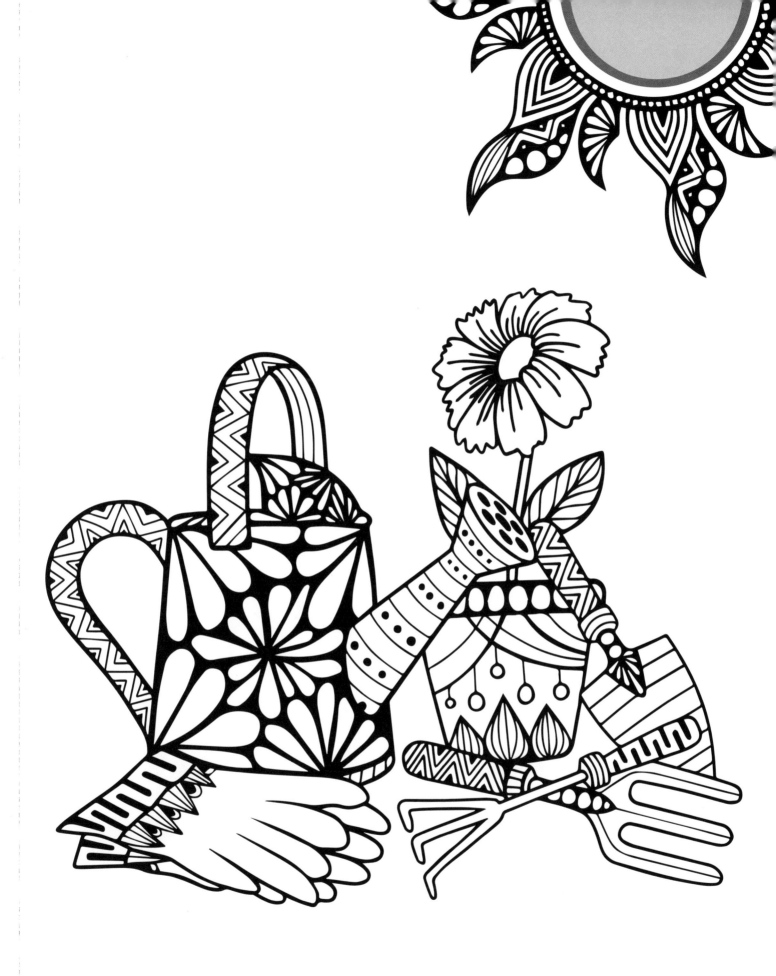

Spend Time in Nature

Time spent in nature is restorative. A natural setting can diminish feelings of anxiety or depression, lower blood pressure, and boost mood and energy levels. Sunlight is an important source of vitamin D (though it's important to not get too much sun!). For these reasons and many others, it is important to regularly spend time outside!

CREATE

Ask a friend or loved one to spend time with you in a natural setting. Take this book (or just the next page) with you, along with your favorite coloring tools. Carefully observe all that is around you. Using the design on the next page, color plants, animals, and other outdoor elements as you notice them.

CONNECT

What is the weather like outside? Is the sun warm on your skin, or is there a chilly breeze? Do you hear birds chirping? What about other sounds? What does it smell like outside? Take time to notice how your senses are fully engaged when you are in nature.

REFLECT

Did you ever vacation at a national park, or another exotic location where you spent time in nature? Where did you go? Who were you with? What was unusual or exciting to you?

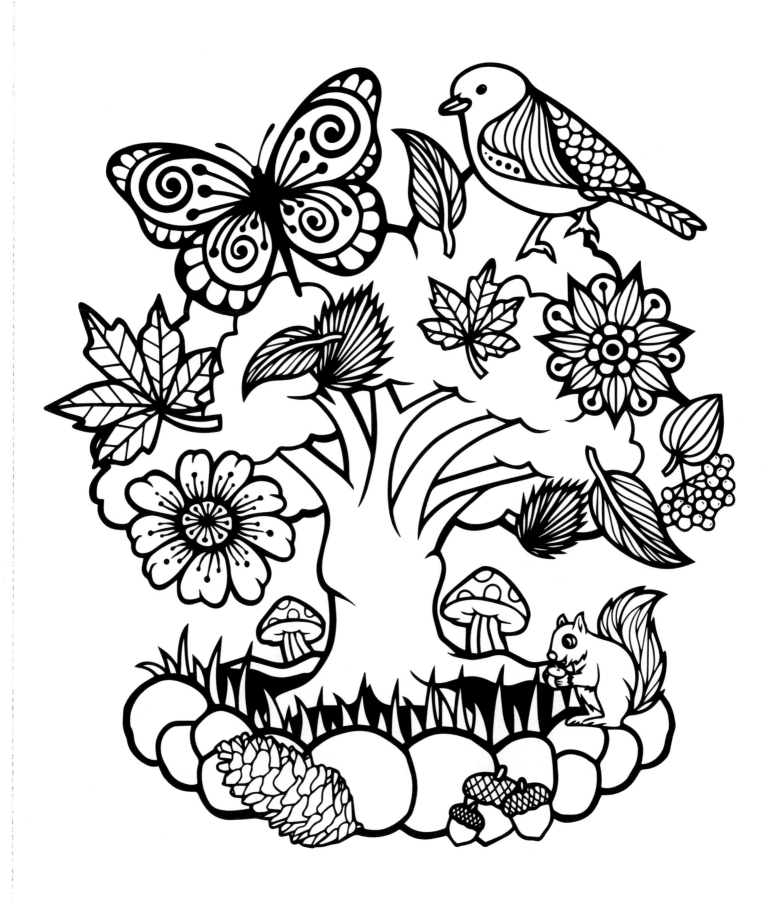

Move Your Mind

OTHER PARTS OF THIS BOOK emphasize the importance of nourishing and exercising your body. Consider then that the brain is the most important organ in the body. It is just as important (or even more so!) to feed and exercise the mind.

This chapter discusses effective ways to stimulate the mind. Music and art provide a connection to something deep within all of us, and have the power to evoke strong emotional responses and trigger distant memories. Seeking the arts and opportunities for new adventure enriches daily life.

MARIA'S TIP

Create!
Whether you think of yourself this way or not, you are a creative person! Music and art can be passively enjoyed, certainly, but they also offer powerful ways for you to express yourself! What do music and art add to your life?

Listen to Music

Research has shown that music has therapeutic potential for people with Alzheimer's. Music can help them to retrieve precious memories and evoke deep emotions. Certain music can soothe and calm, while other music can energize—you can't help but tap your toes! Ask your loved one what music they enjoy. If they don't remember, look up songs from when they were young, and make a soundtrack of their life. Play music that might jog their memory. I remember long after my father forgot my name, he still remembered certain music from his younger years.

CREATE
Music and color are often described using the same language! Both can be bright and lively, or quiet and reflective. A song has a tone, just like color. Listen to music as you color the image on the following page. How would you describe this music? Is it lively, or calming? Does your color palette reflect the music you are listening to?

CONNECT
Talk with your caregiver, a loved one, or friend about music. What kind of music do you enjoy? What kind of music do *they* like? Have fun with music! Make a playlist together, turn on some the music, and dance!

REFLECT
What does music mean to you? Listen to some songs from when you were young. Is there a special song that you remember? How did you feel when you first heard it? How does it make you feel now?

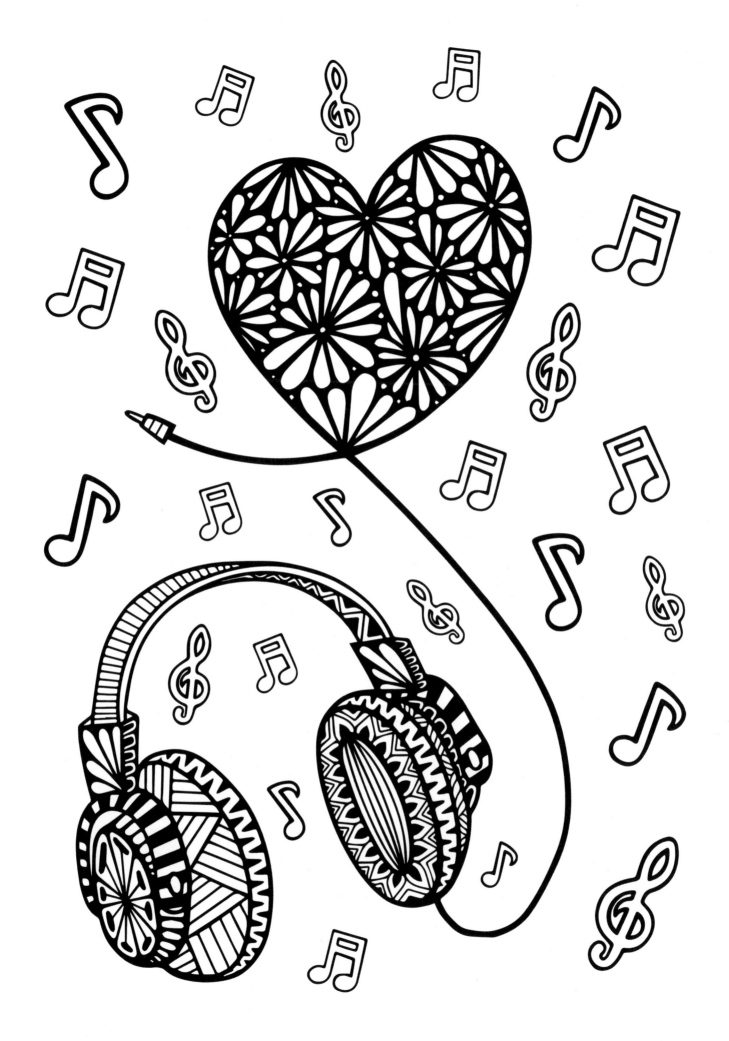

Create Art

Like music, art offers many opportunities for creative expression. Drawing, painting, and other forms of art are not linked to language, and yet they offer new and different tools for communicating and expressing thoughts and emotions. This may be particularly powerful for people with Alzheimer's.

CREATE
Music and art both offer ways to embrace creativity. Color the frame on the following page, and create your own art within the frame. You are a creative person!

CONNECT
What kind of artwork would you like to do? Ask your caregiver to help you to assemble the proper tools. What feelings or ideas would you like to convey with your art? Enjoy the opportunity to express yourself in a new and different way!

REFLECT
Has art played a role in your life? Were you artistic as a young person? Have you ever visited a museum or art gallery?

Evoke Memories

From the nifty '50s to the crazy '80s, we associate different eras with specific music, art, cultural phenomena, and special memories. Different parts of the brain are used to store short-term and long-term memories. It makes sense, then, that people with Alzheimer's may be able to remember significant people and events from the distant past, but struggle to remember a detail from the previous day.

Research tells us when people are exposed to music and art, different parts of the brain are activated. As a result, memories may be recalled, or emotions may be suddenly evoked. These experiences can be quite poignant, creating new points of connection for people with Alzheimer's and their loved ones.

CREATE
As you color the following page, think about some popular colors from each decade. For example, the avocado green of the 1970s!

CONNECT
Think about the art and music of your favorite decade. Play a song from this era, or create a piece of artwork that reflects what you remember from this decade.

REFLECT
Do you have favorite songs or favorite performers or musicians from a certain decade? Do you have particularly fond memories from this period in time?

1950s

1960s

1970s

1980s

Embrace Experience

Life is all about embracing experiences and seizing opportunities! For people with Alzheimer's, it's important to maintain an interest in hobbies and to continue to connect with friends and loved ones.

This chapter explores music and art as a means of fulfilling self-expression, and as powerful vehicles for evoking memories, prompting conversation, and making meaningful connection. As a whole, this book offers many ideas for keeping the mind, body, and spirit active and engaged. Remember that the point isn't an "end result," but rather the process of trying something new and finding ways to engage, connect, and enjoy life!

CREATE
As you color the image on the following page, be as bold and free as you like in choosing colors.

CONNECT
Talk with your caregiver about planning a special experience. There are plenty of ways to try new things while still remaining in your "comfort zone."

REFLECT
What kinds of activities or outings did you enjoy when you were young? Did you go to dances or to concerts? Have you ever been to a play or visited an important museum?

MARIA'S TIP

There's always tomorrow.
Life can feel overwhelming at times. A night of sleep is restorative, and we can wake rejuvenated and ready for a new day. Remember, there's always a tomorrow, a new day to start fresh, filled with people we love and rewarding experiences.

Sleep

SLEEP NEEDS VARY FROM PERSON TO PERSON, but a good night of rest is an essential part of overall health and well-being. Sleep is vital to help the body maintain and repair itself, and is necessary for proper cognitive function. Consistently getting enough sleep can foster creativity, help with maintaining a healthy body weight, and aid in improving concentration, among many other benefits. Researchers are learning more and more about the importance of sleep and its role in helping people to live healthy and productive lives.

This chapter reviews some important techniques that can help to prepare for a good night of sleep, including deep breathing and relaxation. It explores the importance of devoting time to "wind down" at the end of the day, as well as ways to feel comfortable and secure when readying oneself for sleep.

Breathe

Close your eyes; take a deep breath in through your nose, and slowly exhale out of your mouth. Feel your shoulders drop. As you continue to take deep, cleansing breaths, notice how the muscles in your face and jaw relax.

Encourage your loved one with Alzheimer's to focus on breathing at least once a day. Breathing deeply has the power to help alleviate stress. Deep breathing can also help to calm and unwind at the end of the day and provides the brain with the oxygen it needs for a restful night of sleep.

CREATE
Before you begin to color, close your eyes and take several deep breaths. Inhale through your nose, and exhale out your mouth. Visualize what you would like your final, colored image to look like. Continue to be mindful of your breathing as you color the image on the following page and try selecting colors that feel relaxing to you.

CONNECT
When you breathe deeply, what physical changes do you notice in your body? How do you feel when you take time to slow down and notice your breathing patterns?

REFLECT
What is the best way you have found to cope with stressful situations in your life? Do you think that breathing deeply is helpful in stressful situations?

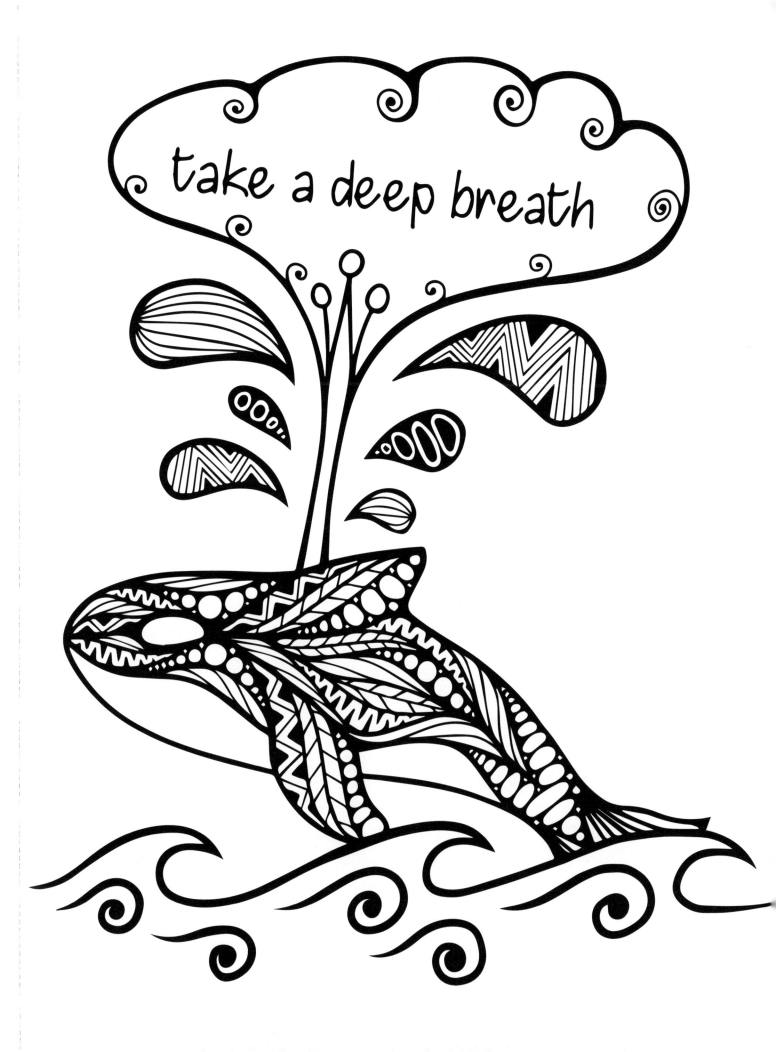

Wind Down

It can sometimes be difficult to slow down and unwind from the day. In the evening hours, it is a good idea to follow a routine that can help to prepare the mind and body for a restful night of sleep.

Did you know that symmetry in design can have a calming effect? Coloring is an activity that may help to calm and relax a person with Alzheimer's at the end of the day.

CREATE
Half of the design on the following page has been completed. Simply match the colors to complete the other half at your own pace in as many sessions as you'd like. Try coloring this page in the hour before bedtime!

CONNECT
In this book, you have learned several techniques that can help you to wind down. As you color, try some deep breathing exercises, or ask your caregiver to turn on some calming music.

REFLECT
What have been some of your favorite ways to unwind over the years? Did watching television or listening to music help you to fall asleep? What routines do you use now to help get ready to drift to sleep?

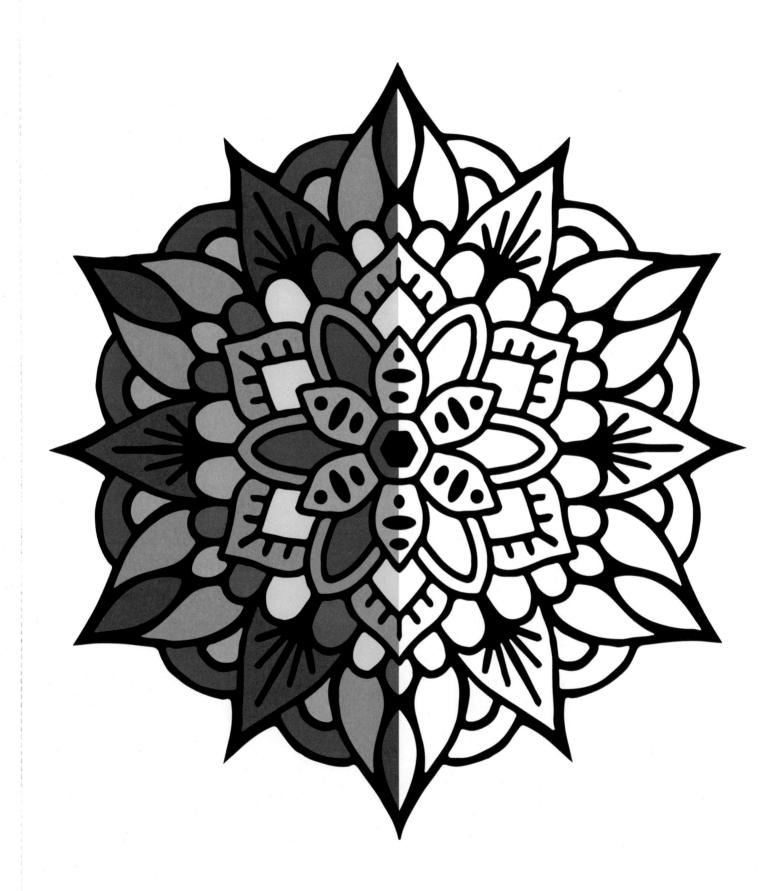

Get Comfortable

Just as a routine prepares one for the day, a bedtime routine can help to set the stage for a restful night of sleep. To prepare for bed, it is helpful to clear clutter in the bedroom and turn down the covers. It may be helpful to dim the lights or to play soft music from a radio. When bedtime comes, remember that a darkened room is considered optimal for a good night's sleep. Most important, though, is that the person with Alzheimer's feels safe and comfortable.

CREATE
As you color the pattern on the following page, use colors you think will help you to relax and feel sleepy.

CONNECT
What makes *you* feel comfortable as you get ready for sleep? Do you have a favorite stuffed animal, a comfortable pair of pajamas, or a cozy blanket?

REFLECT
In your life, have you been a night owl or an early bird? How has your bedtime schedule changed over the years?

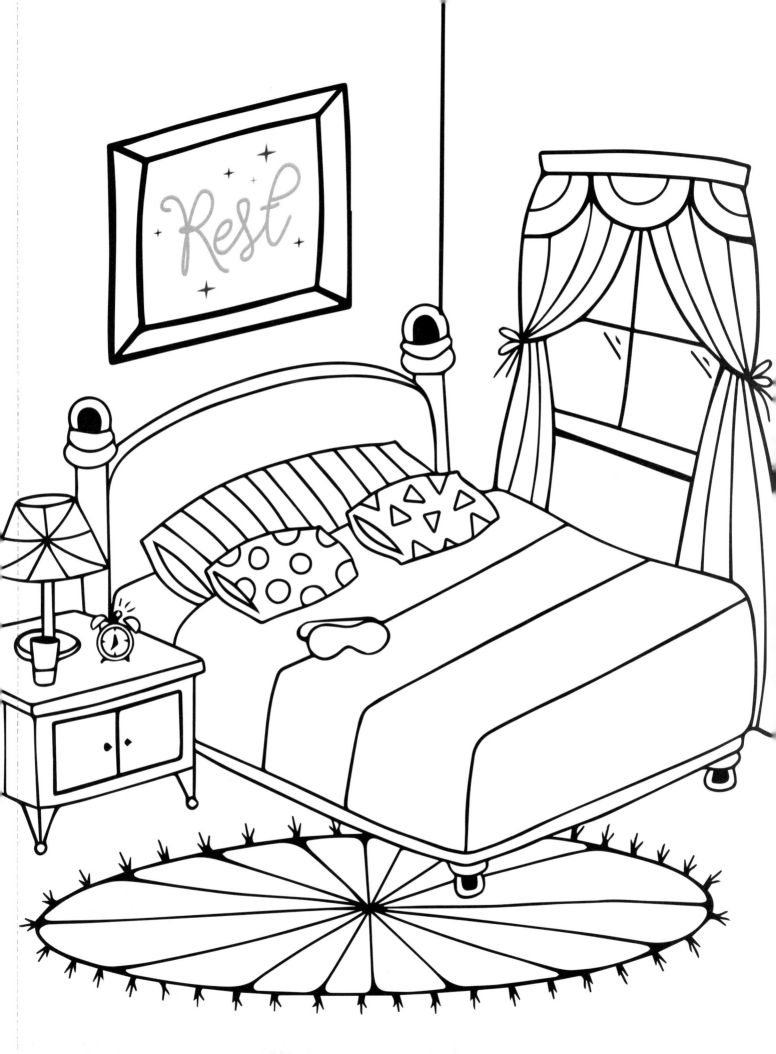

Dream

Why do we dream? No one fully understands why we dream, but scientists theorize that dreams may help people to file away memories. What we do know is that in a dream, anything can happen!

CREATE
Dreams don't occur only at night! As you color the image on the following page, let your mind wander and enjoy the freeing sensation of a daydream.

CONNECT
What do you think is the purpose behind dreaming? Ask your caregiver or a loved one about a recent dream he or she has had.

REFLECT
Have you ever experienced a recurring dream? What about a dream that was particularly vivid, or that seemed symbolic?

Maria Shriver

Maria Shriver is a mother of four, an Emmy & Peabody award-winning journalist and producer, a New York Times best-selling author, an NBC News Special Anchor, and the founder of Shriver Media—a for-benefit enterprise that believes media can be used as a force for good in the world.

Shriver is also one of the nation's leading advocates for families struggling with Alzheimer's disease, with over 14 years of boots-on-the-ground activism, journalism and testimony about the disease and the future of America's brains. Her father Sargent Shriver was diagnosed with Alzheimer's in 2003 and passed away in 2011. Since then, she has used her family's story as a means to help the millions of other families affected by this devastating disease.

In addition to reporting on Alzheimer's for NBC News, Shriver has also released groundbreaking reports of her own that shed new light on the impact of the disease. In 2010, her groundbreaking report *The Shriver Report: A Woman's Nation Takes on Alzheimer's* was the first to uncover that Alzheimer's disproportionately affects women. Shriver founded The Women's Alzheimer's Movement, a global alliance of individuals, organizations, researchers, foundations, influencers and industry leaders, to find out why it is that women receive two-thirds of all diagnoses.

Shriver has also written New York Times-bestselling books and produced award-winning film and TV programs that have furthered the public's understanding of Alzheimer's. In 2014, she executive produced the Academy Award-winning film "Still Alice," which stars Julianne Moore and tells the story of a woman affected by early onset Alzheimer's disease. She also co-executive produced the Emmy Award-winning four-part HBO series "The Alzheimer's Project," which premiered in 2009 and helped millions of people learn about and better understand how to live with the challenges of the disease. One of the films in the series called "Grandpa, Do you Know Who I Am?" was honored by the Academy of Television Arts & Sciences for exemplifying "television with a conscience" and was based on Shriver's best-selling children's book dealing with Alzheimer's.

Shriver believes we all have the ability to create positive change in the world as "Architects of Change." Through Shriver Media, she produces original digital content, live events, books, documentaries and films to elevate the voices of individuals who are Moving Humanity Forward.

Shriver continues to use her voice to advocate for Alzheimer's and dementia patients, as well as their family members and other caregivers. In 2017, she received the Alzheimer's Association's first-ever Lifetime Achievement Award for being such a groundbreaking voice in the Alzheimer's community.

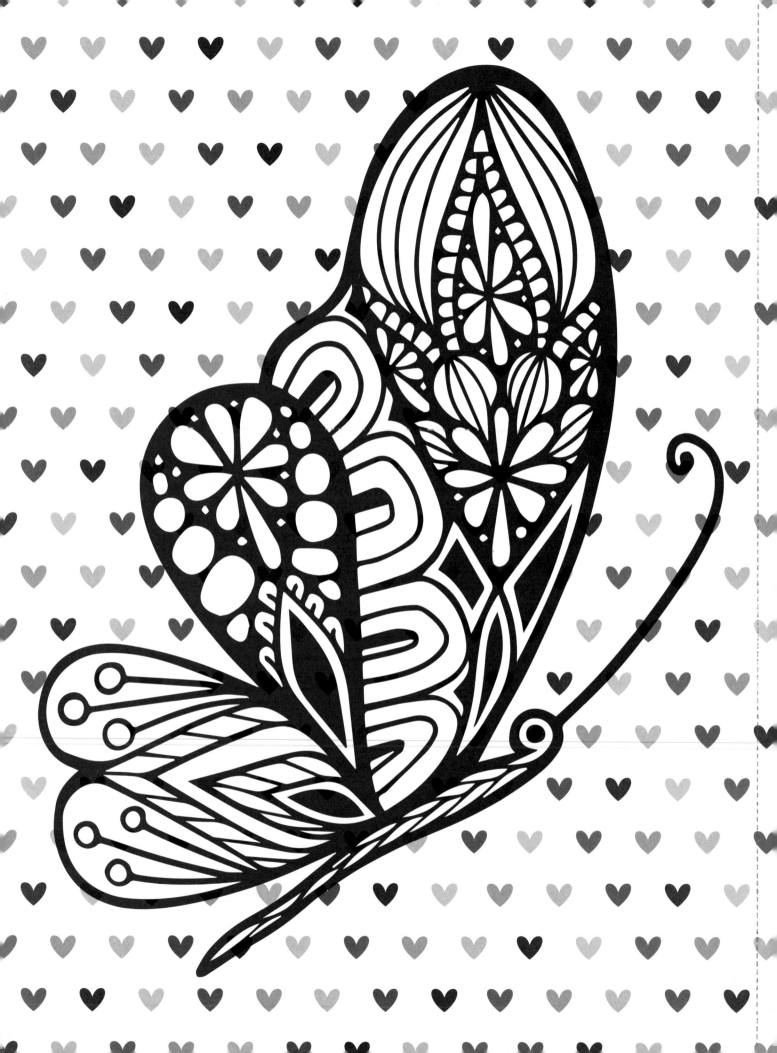

With Gratitude

This project means so much to me, and it came to life with the contributions and insights of so many people.

To my publishing partners at Blue Star Coloring, thank you. Your mission to inspire creativity and wellness through creative expression aligns seamlessly with the vision and hope that has guided *Color Your Mind* through its development. Peter, your immense creativity, commitment and patience never faded during the process and for that I'm so grateful. I loved working with you.

My great thanks to Brita Lynn Thompson, whose creativity and skill in illustration add so much grace and beauty to this project.

Thank you to Jan Miller, Patti Peterson and Shannon Marven who link arms with me on many projects and leave their indelible impression on the outcome. I'm so blessed to work with you all.

I recognize and thank the many researchers who work tirelessly toward finding a cure for Alzheimer's. I applaud and am grateful for my friend Dr. Richard Isaacson who reviewed this book to make sure it is correct. I want to thank Robin Ketelle, RN, MS at UCSF whose comments helped us to get the information just right.

I particularly thank those who share their talents and passion through their involvement in The Women's Alzheimer's Movement™, especially Erin Stein and Sandy Gleysteen. Together, along with the millions of women and the men who love them, we are committed to finding out why Alzheimer's discriminates against women. We believe that by answering the question of why women are disproportionately affected by Alzheimer's, we will unlock the other mysteries surrounding this mind-blowing disease and that will lead to a cure for all.

Thank you my friend, Marc Thaler. You brought so much creativity and care for this book. Thank you for taking an interest. I am grateful for your friendship.

Thank you to Sister Conchessa Johnston of The Village at Incarnate Word in San Antonio, Texas. Your insights and experience doing art therapy with memory care patients were invaluable in shaping the direction of this book.

I am also blessed to have the love, support and encouragement from my family—especially you Katherine, Christina, Patrick, and Christopher. I love you all to the moon and back. Nothing makes me prouder than being your mother.

And last, my love to the millions upon millions of people living with Alzheimer's, and to the many more who love and care for them. You inspire me with your strength, courage, and grace. I hope you know you're not alone. We're not alone. There is support and help for you, even within the pages of this book. I wish we had this coloring book for my father to help us navigate the journey. It would have given me a fun activity to do with him, and it would have given me information and hope. My hope is that this beautiful book will inspire you, inform you, and bring you closer to someone you love.

With love,
Maria

Thank you for coloring with me!

I Love You